COMPOSITION WITH CAT

Lost Masterpieces of the Twentieth Century

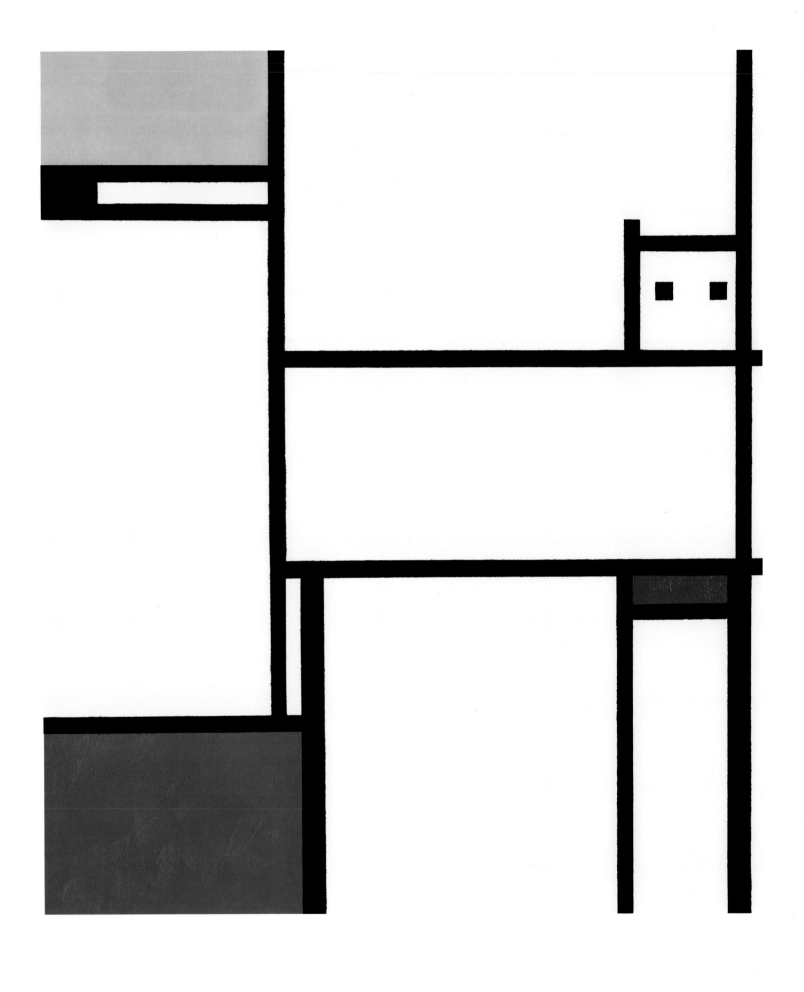

COMPOSITION WITH CAT

Lost Masterpieces of the Twentieth Century

William Warmack

TEN SPEED PRESS
Berkeley, California

Ten Speed Press
P.O. Box 7123
Berkeley, CA 94707

Distributed in Australia by E.J. Dwyer Pty Ltd; in Canada by Publishers Group West; in New Zealand by Tandem Press; in South Africa by Real Books; in the United Kingdom and Europe by Airlift Books; and in Malaysia and Singapore by Berkeley Books.

Additional art by Paul Hedrick
Text and cover design by Nancy Austin
Text by Mariah Bear
Photographs by Jonathan Chester
Author photograph by Paul Schulz
Printed in Hong Kong

Library of Congress Cataloging-in-Publication Data
 Warmack, William.
 Composition with cat : lost masterpieces of the 20th century / William Warmack.
 p. cm.
 Catalog of an exhibition held at the Philip Wood Gallery, Berkeley, Calif. in 1997
 ISBN 0-89815-826-5 (paper) / 0-89815-923-7 (cloth)
 1. Cats in art--Exhibitions. 2. Lost works of art--Exhibitions. 3. Art, Modern--20th century--Exhibitions. I. Philip Wood Gallery. II. Title.
 N7668.C3W37 1997
 704.9'432975'07479467--dc21 97-1930
 CIP

1 2 3 4 5 — 00 99 98 97

ACKNOWLEDGMENTS

In creating this work, I am especially indebted to my old friend Paul Hedrick for his insight and brilliantly witty contributions; to Wernher Krutein for his special technical assistance; to Sandra Evans for her research, wit, and daily presence; and to M.T. Caen, my esteemed agent, for her editorial prowess and for keeping me sane.

For my parents, fishing in nirvana.

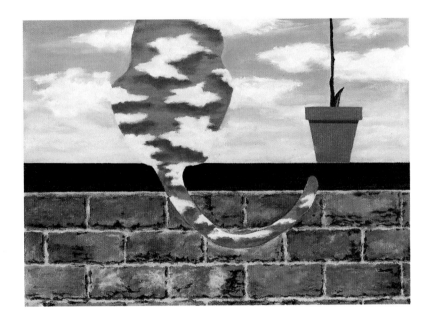

Ceci N'est Pas un Chat (detail)
René Magritte?
Oil on canvas

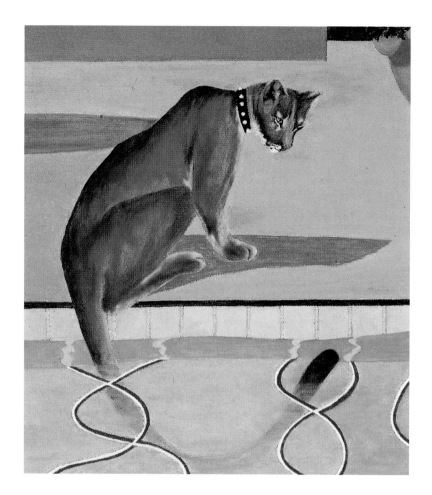

George's Cougar (detail)
David Hockney?
Acrylic on canvas

CONTENTS

CURATOR'S PREFACE

Every private art collection has a story to tell—indeed, many stories: the loves, desires, obsessions of the collector; his or her place in the world and in history; the strivings and triumphs of the artists themselves. An individual's collection contains all the ingredients for an epic, a romance, a comedy, a tragedy—or a mystery.

The collection presented in the following pages tells some of the most dazzling stories I have ever encountered. Each piece in this exceptional group of thirty paintings is glorious, a masterpiece of twentieth century art. But not one of them is signed; none has ever been exhibited, sold at auction, written about; none has left a paper trail or a trace of rumor. Their provenance was and remains a mystery—a tantalizing, delectable, inviolate mystery.

The only tale I have to tell, then—and it is remarkable enough in itself—is the story of how I became involved with this collection (embroiled might be a better word) and how this book came to be.

It started on a bright day in September, two years ago. I was at that time, as I am now, employed as curator of the Phillip Wood Gallery of Nonprimate Art in Berkeley, California. A letter courier managed to find me in the disordered hodgepodge that serves as my office on Solano Avenue. Impressive wax-sealed documents informed me that the gallery had inherited an important art collection from a titled Russian emigrée, whose only conditions were that she remain nameless and that the collection remain intact.

As we're a rather specialized gallery, I could only assume the collection had some connection to our international reputation as a venue for

nonprimate art, but aside from a large brass key and the address of the estate's lawyers in Barcelona, there were no further clues.

Fifteen hours later I was in the shuttered offices of the Barbieri law firm, where I received directions to the cliffside villa and wine cellar where the paintings had been stored. All the diffident Spaniard would divulge was that the princess had been a reclusive artist, had died at the age of ninety-one, and had no known relatives. After securing the necessary documents allowing removal of the collection from Spain, I booked passage on the overnight ferry to Ibiza and slept fitfully.

My curiosity was further heightened upon exploring the rundown villa and finding the heavily barred doors to the wine cellar built into the cliff below. Inside it was surprisingly cold, and replacing the traditionally stacked oak barrels in the narrow cavern were scores of draped canvases of all sizes, facing each other like some surreal chess set. After lighting the ceiling lanterns, I unwrapped a small canvas and fell back in shock. It was—or it seemed to be—a Magritte, a beautiful, cloud-filled Magritte. The next canvas was a Mondrian, followed by a de Kooning, and then, my god, a Rothko. An oak flat file contained tissue-wrapped photomontages—could this be a Claes Oldenburg? And a Christo? In the corner, swathed in cloth, stood two sculptures—for all the world looking like a Louise Nevelson and a Jim Dine. The cavern practically vibrated with priceless colors and forms.

As I unveiled more and more artworks, a strange pattern slowly emerged. A common thread bound these works together—they all, without exception, treated feline subjects. Then I noticed, tucked into the

stretcher of the Magritte, a photograph of a cat. When I checked, every piece had a photograph of a cat or cats, with names written in a firm but fading black script on each photo's back.

While I was trying to take in this new development, a moving shadow caught my eye. A huge cat had entered the cellar and boldly approached me, purring madly. Her jeweled collar proclaimed her name to be Tati; I thought surely she must have been owned by my patron. Tati seemed to smile at my bemusement, and right then I decided to take her along on the long flight home.

Three days later, with my cargo—living and inanimate—safely secured in the belly of the 747, I settled into my window seat and turned my mind again to the puzzle I had been presented—an enigma that still haunts and teases me.

How could this mysterious woman come to possess what appeared to be never-before-seen modern masterpieces? Could they possibly have been commissioned, or was the cat as Muse so universal an influence in the blazing genius of these artists that each of them was compelled to work feline themes into their art? Perhaps this Russian emigrée was a gifted forger—Ibiza certainly has been home to its share. And what of the photographs—a varied accumulation of informal snaps and posed portraits—that were paired with each of the artworks? Were these felines models or muses, or were my explorations in the field of nonprimate aesthetics about to uncover an entirely new level of artistic achievement: in short, could these cats themselves be the artists? When I reached this point I decided I was feeling the effects of shock, jetlag, and lack of sleep,

so I ordered another single-malt scotch and drifted off into dreams of giant cats and great color-filled catacombs.

Back in Berkeley, I threw myself into preparing the pieces for exhibition in the gallery. My lack of information about the artworks was intensely frustrating, but I was hopeful that with diligent research I could piece together the histories of most, if not all, of them. I was not fortunate: in over two years of working on a project that began to take on the proportions of a personal crusade, I found nothing verifiable.

As my research progressed, however, I did discover a startling fact: all of the artists whose styles are so closely represented did, indeed, have beloved feline companions—cats whose names, furthermore, matched those penned on the backs of the photos I found. All of them were also, it appears, known to the mysterious collector. As to how that sly emigrée—artist, patron, and felinophile—came to possess them all—well, I am becoming reconciled to the idea that I may never know.

As curator and trustee of this glorious but exasperating exhibit, I have played with many tempting assumptions and possibilities in trying to put together a cohesive story for these artworks. I remain perplexed; now all that I ask as you view these works is that you keep an open mind. Read on, but leave your assumptions at the door, next to the litter box.

Now it is time to let the collection speak for itself—to let the Mews be the Muse.

William Warmack
January 1997

PLATES

Pounce
Alexander Calder?
Collage of colored paper on board

While Alexander Calder is perhaps best known for his dramatic kinetic sculptures called mobiles, their origins were found in the flat planes and primary colors of his stabiles. This cat's playfully curled tail and spring-loaded haunches exude a whimsy like that which characterized Calder's later work.

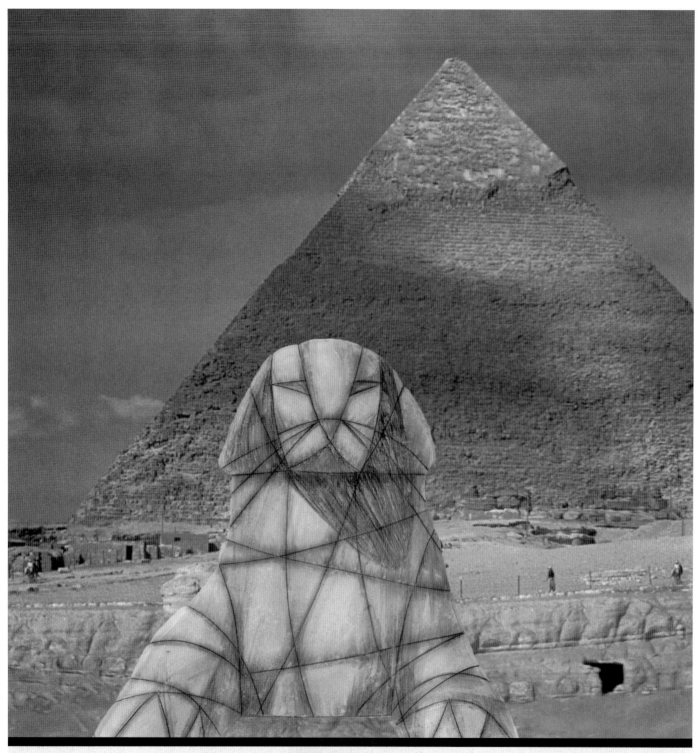

Pyramid of Khafre
and the
Sphinx

Mortuary Temple

Causeway

Great Sphinx

Sphinx Temple

Subsidiary Pyramid

Mastabas and Rock-cut Tombs

Valley Temple

Wrapped Sphinx
Christo?
Photomontage

Clearly, this artwork was never actually realized—perhaps the Egyptian government refused. Christo would often create photographic collages for projects that were never completed (such as his mid-1960s concept *Two Lower Manhattan Wrapped Buildings*), so this piece may well have been created as a monumental feline tribute.

Gotham Cat
Willem de Kooning?
Oil on canvas

Willem de Kooning's greatest work boldly and successfully blurs warring visual and emotional elements with his trademark abstract expressionist brushstrokes. The cat pictured here, soft and fluffy yet armed with sharp teeth and claws and blazing eyes, succinctly exhibits such a fusion of dissimilar elements.

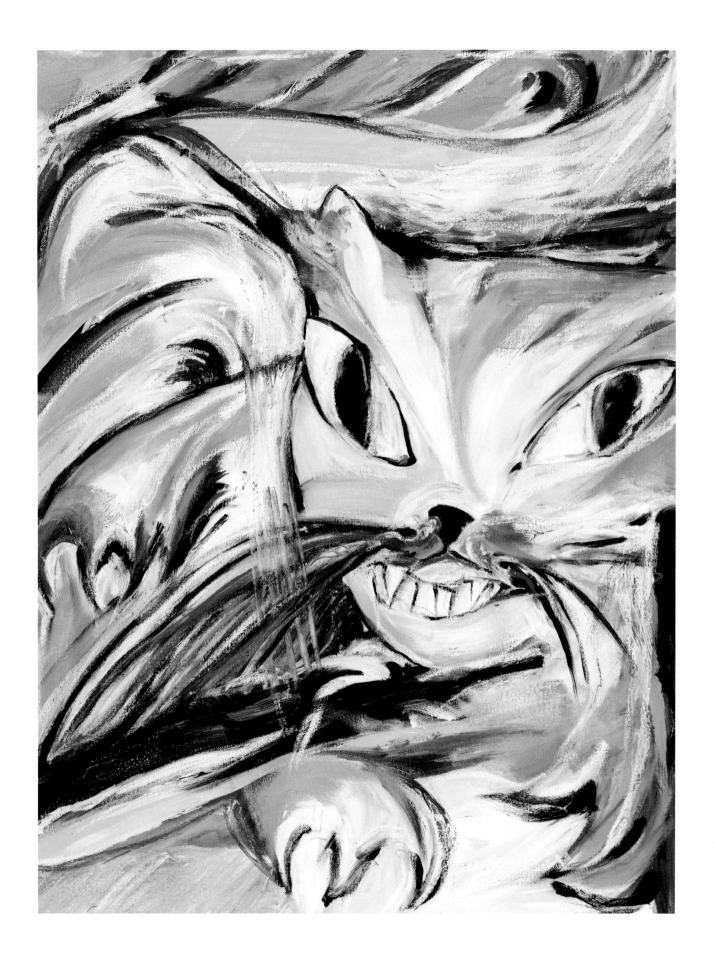

Four Feet of Fur
Jim Dine?
Nylon carpet, plywood, acrylic paint, wire, acrylic chew toy

While he later rejected both sculpture and the ubiquitous (and increasingly commercial) "happenings" that punctuated pop art, Jim Dine remains best known for his innovative sculptures that combine painterly techniques with odd "found objects." If this is not a stunning example of his work, it's certainly something very similar.

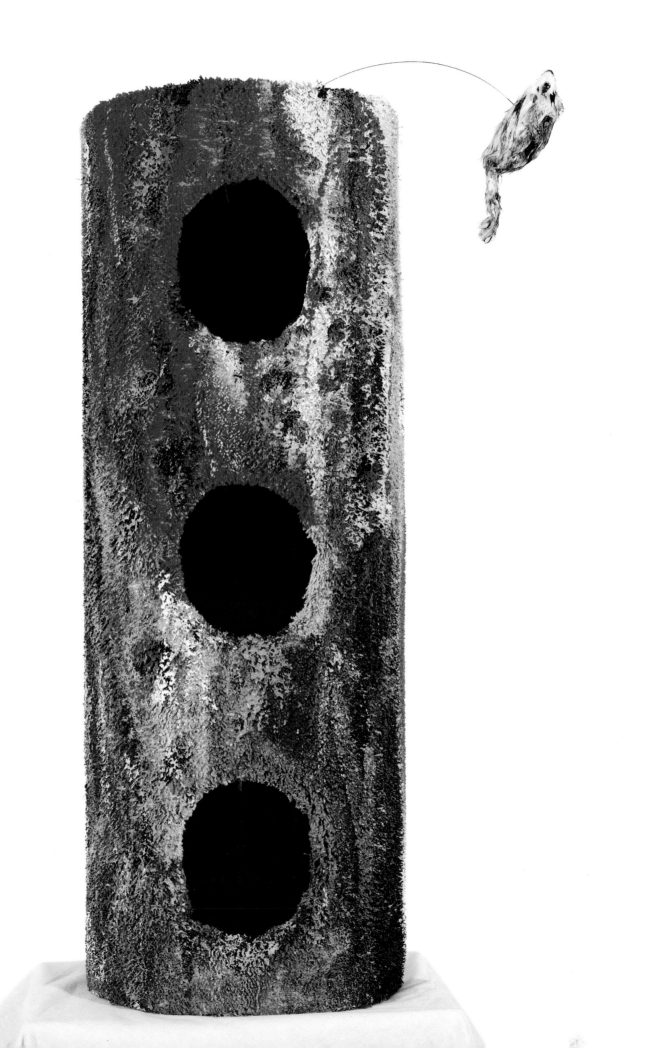

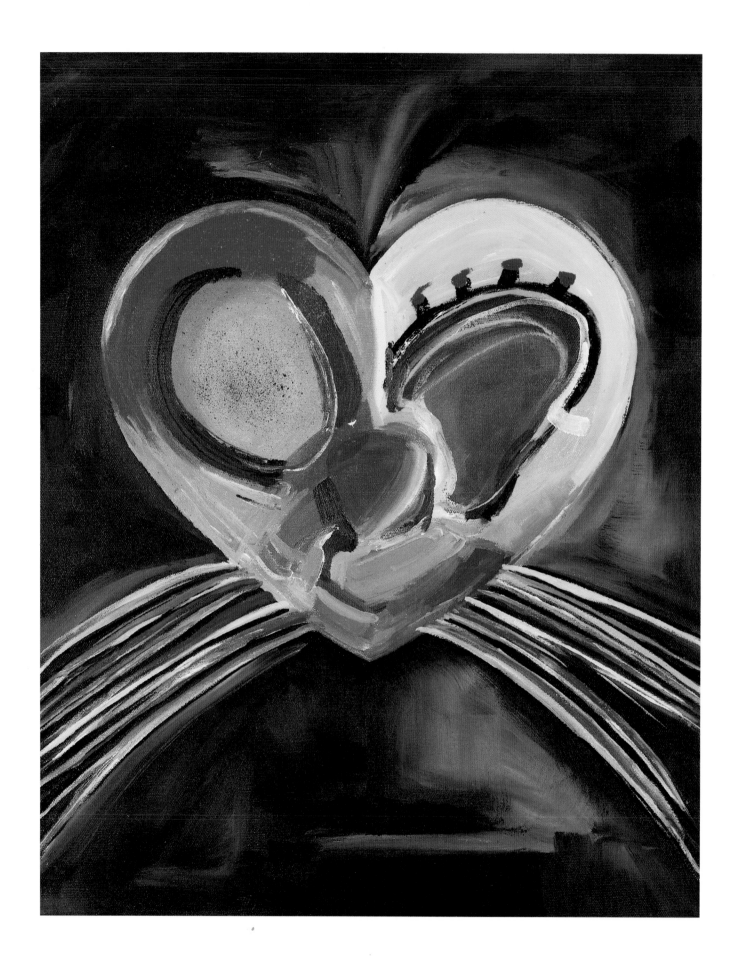

COMPOSITION WITH CAT

Heart #7
Jim Dine?
Oil on canvas

Criticism of Jim Dine's prints in the 1960s concentrated on his use of heart-shaped images and bristly textures, which most writers viewed as symbols of the archetypal male and female displaying their nasty bits. Here, perhaps, the artist portrays yet another bedmate.

Sur le Boulevard
Jean Dubuffet?
Oil on canvas

For an artist who did not have his first exhibition until the age of 43, Jean Dubuffet's output—sculptures, lithographs, gouaches, drawings, and of course his signature oils—was truly prodigious, numbering in the multiple thousands. Is it so unlikely that one piece—such as this, a clear tribute to the elegant lines of the cat (a creature whose lively creative energy could indeed be said to rival the artist's)—could have been missed by his many biographers?

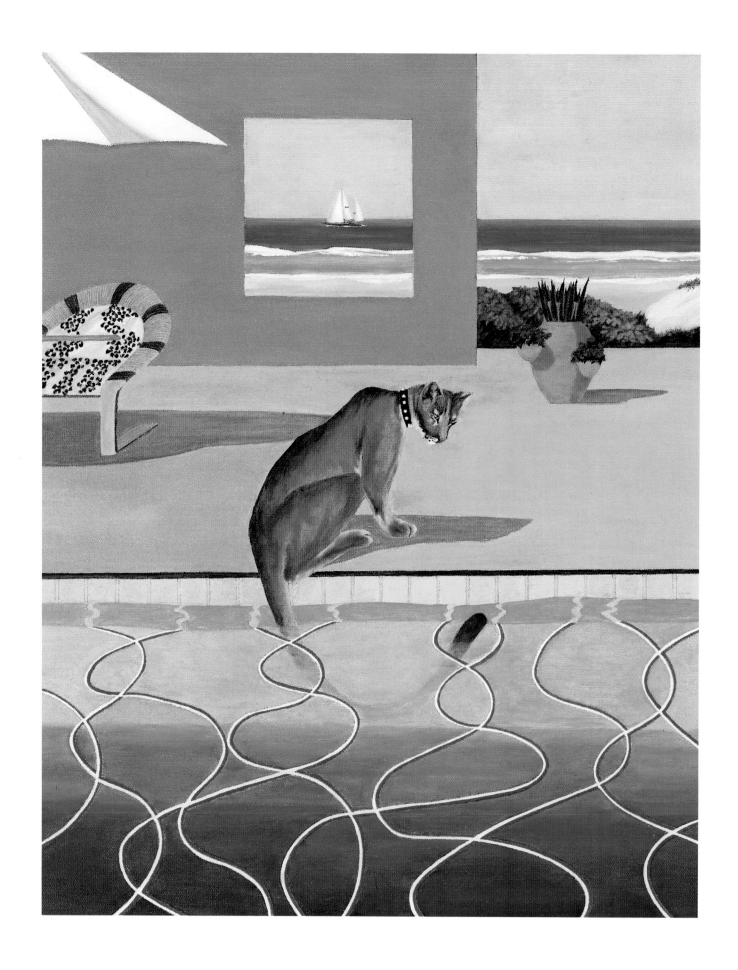

COMPOSITION WITH CAT

George's Cougar
David Hockney?
Acrylic on canvas

David Hockney emerged from a school of revolutionary British artists who simultaneously embraced and rejected nonconformism. He also painted a vast number of swimming pools. After moving to Los Angeles, he switched to acrylics, giving his paintings a flat cast such as that mirrored here in the interplay of cat and water.

Night Watch
Edward Hopper?
Oil on canvas

Edward Hopper's paintings are characteristically bereft of life, or populated with lonely, perhaps somewhat threatening—or more likely, threatened—figures. In this piece, we can imagine his drawing all of these elements together: the indifferent diner; the prowling cat, reminiscent of the prowling men walking the breadlines of the era; and the isolated and imperiled, yet poignantly hopeful, mice, which seem to evoke the defeated, yet defiant, migrant workers photographed so movingly by Walker Evans. The sketch below may be a charcoal study for this piece.

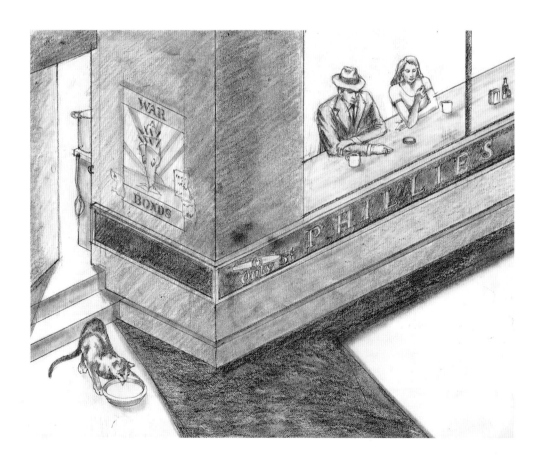

COMPOSITION WITH CAT

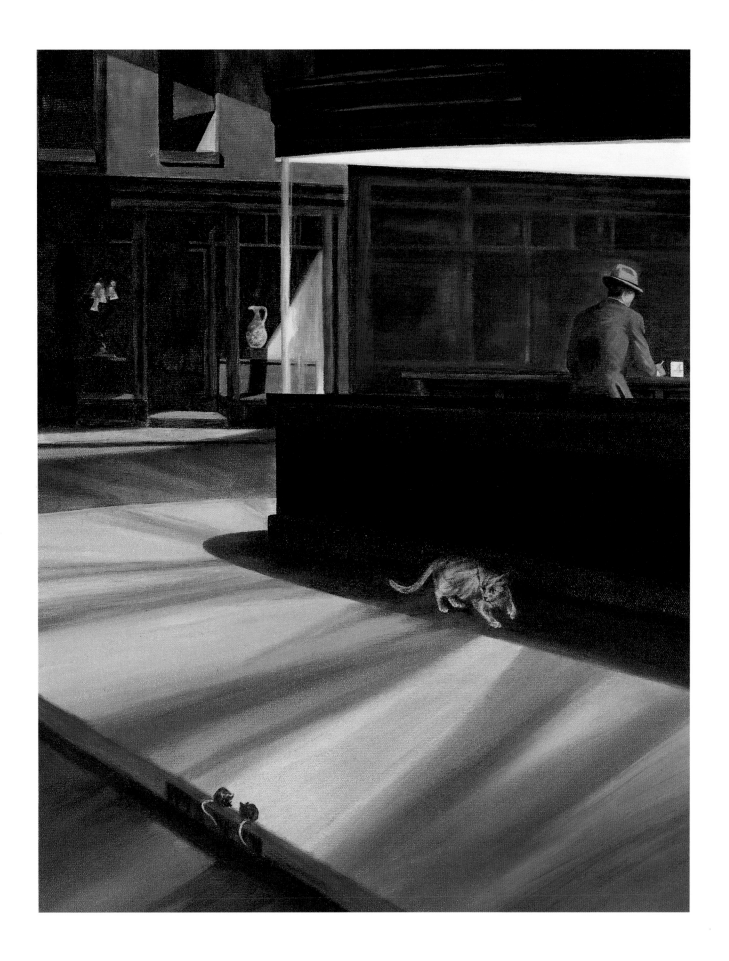

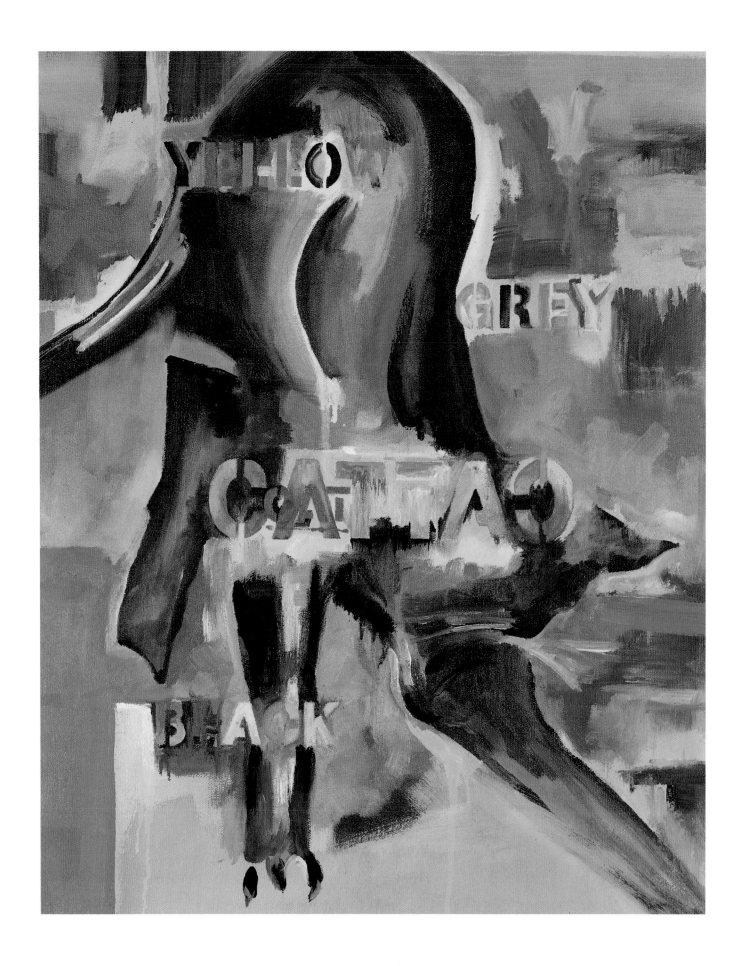

COMPOSITION WITH CAT

Pussboot
Jasper Johns?
Oil on canvas

Jasper Johns, often classified as a proto-pop or neo-dadaist artist, has been described by critics as presenting images that are puzzling in their crypto-abstract quality—figurative yet abstract, clearly labeled yet clouded. Here, in what would appear to be a classic Johns composition, the paint itself calls out to us with an image and a label that say "cat," while simultaneously undermining that image.

Orange Panel
Ellsworth Kelly?
Oil on canvas

Ellsworth Kelly's simple and colorful pieces defy easy penetration. They were considered sufficiently emblematic of a new American vision to win display at the 1966 XXXIII Venice Biennial Exposition, alongside the works of Roy Lichtenstein, Helen Frankenthaler, and Jules Olitski. All were considered "difficult" painters, and Kelly was viewed as particularly interesting because his work did so much with so little. Clearly this can be said of the painting opposite: simple, stark, and monochromatic, it nonetheless pronounces "kitty" in a loud and unmistakably American accent.

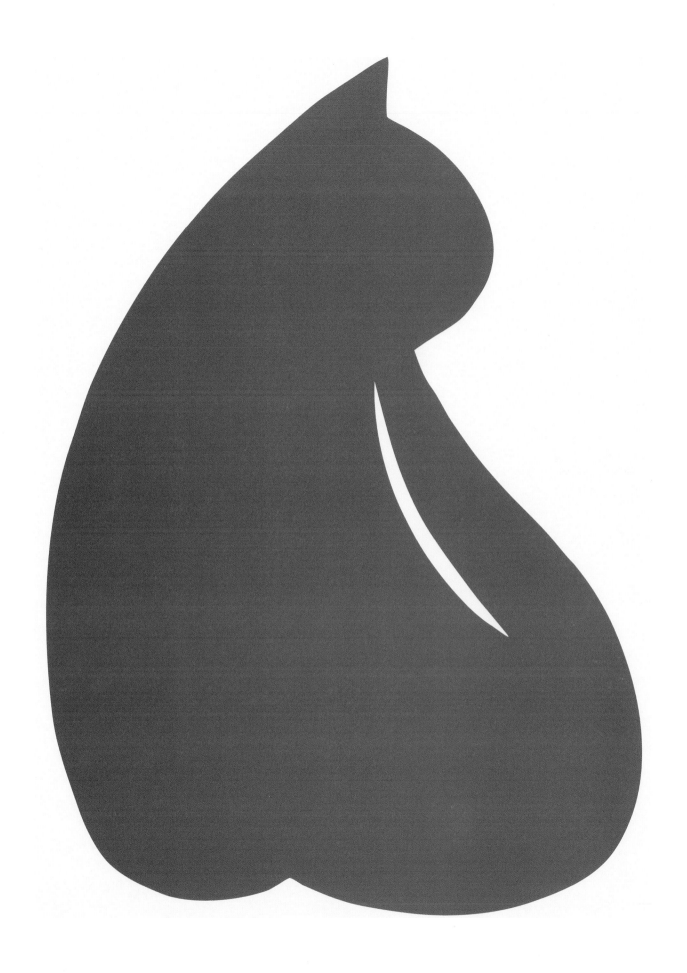

S-Sandra
Roy Lichtenstein?
Oil and synthetic polymer paint on canvas

Roy Lichtenstein burst onto the art scene around 1961, with a comics-inspired look that, while easily classified as pop, had truly never been seen before. What could have inspired such a fascination with deconstructing and recasting art to reflect the more prosaic aspects of newspaper and pulp magazine production? Can anyone who has ever owned a cat and left it alone for an afternoon with the Sunday edition of the *New York Times* really wonder?

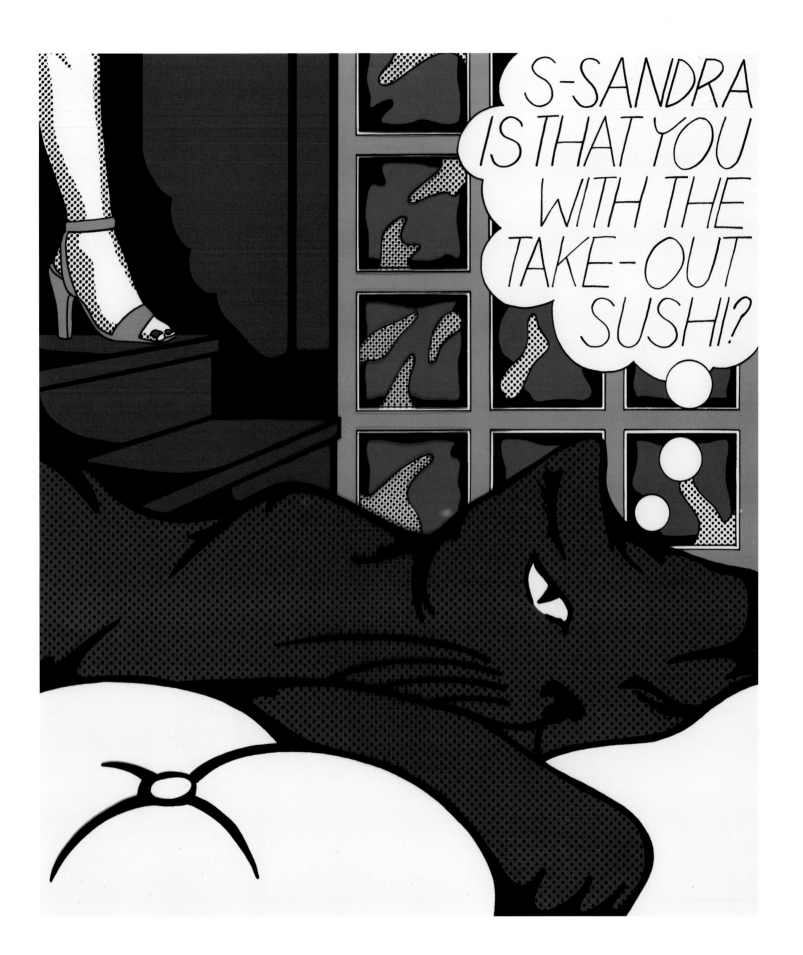

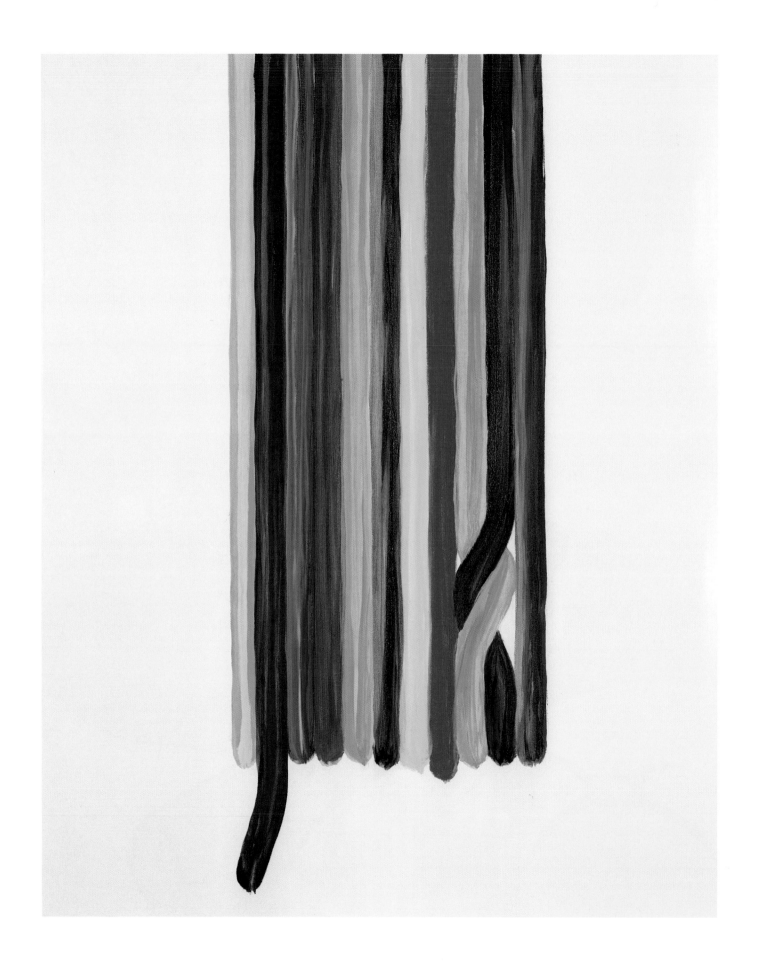

COMPOSITION WITH CAT

Number 11

Morris Louis?

Acrylic paint on unsized canvas

Critics tend to agree that Morris Louis's most important works were also his most mature: the color-stripe paintings that occupied him throughout the latter years of his career. These pieces are best described as spontaneous yet sophisticated exercises in playing with the properties of canvas: occupying it authoritatively while still seeming drawn off in a number of directions. The paintings seem the embodiment of impulsive will. Could a better description exist of the feline personality?

Ceci N'est Pas un Chat
René Magritte?
Oil on canvas

René Magritte rejected most attempts to categorize or criticize his work, saying that "a thing which is present can be hidden, invisible by what it shows." This seems to sum up not only the plate on the facing page, but also the perplexity of anyone who has ever lost a new kitten in a perfectly empty apartment. It is interesting to note that *les chats grands* appear in several authenticated Magritte works, such as the 1941 *Le Mal du Pays* and the 1951 *Souvenir du Voyage III.*

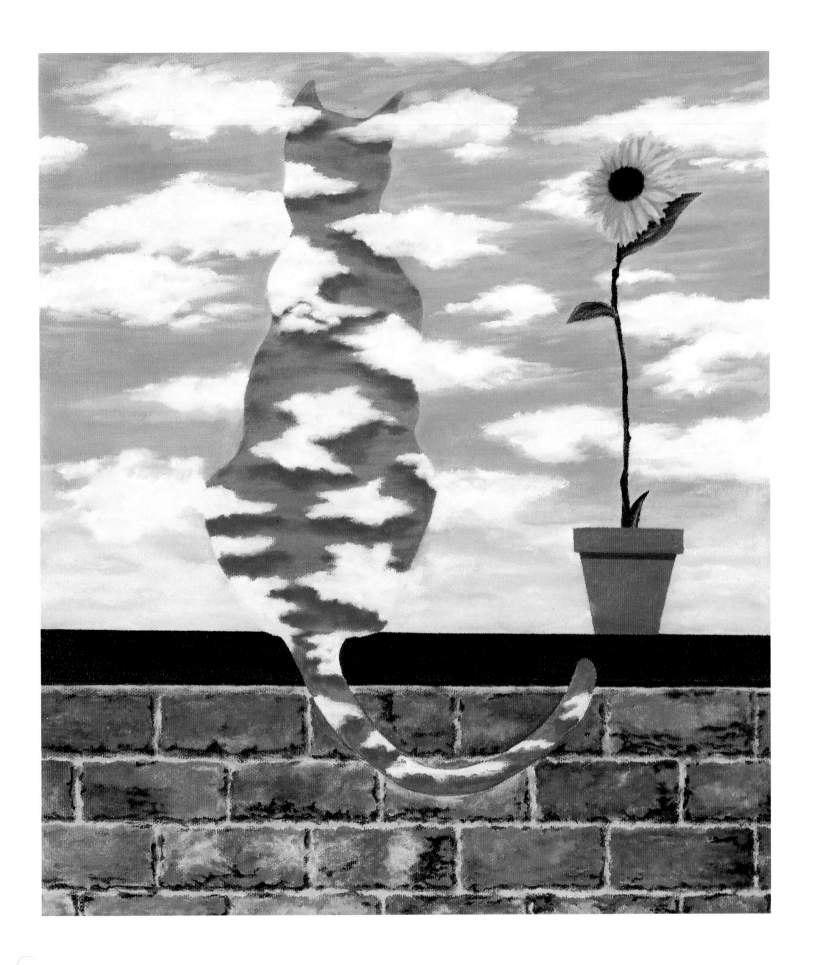

Universe

Henri Matisse?

Collage of colored paper on board

In 1905 a group of young artists held an exhibition that shocked *tout le monde.* The bright colors! The distorted perspectives! The unconventional techniques, such as collage! Surely these artists, particularly their apparent ringleader, Henri Matisse, must be mad: hence, the movement spearheaded by Henri was termed fauvism, from the French word for wild beast. How apt, then, it would be for this middle-class wildman to create work centering on that most wild of domesticated beasts, the ever-savage house cat.

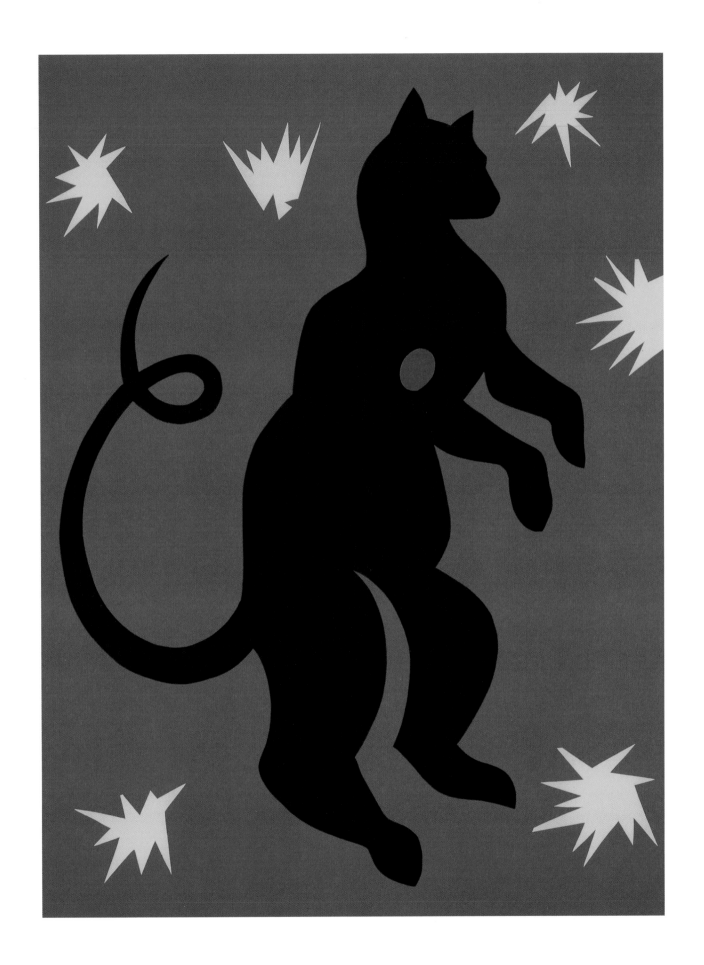

COMPOSITION WITH CAT

Harmony in Blue
Henri Matisse?
Collage of colored paper on board

Late in life, Matisse criticized the École des Beaux-Arts, where he had received much of his formal training, saying, "The teachers at the Beaux-Arts used to say to their pupils 'copy nature stupidly.' Throughout my career I have reacted to this attitude, to which I could not submit; my struggle gave rise to various changes of course, during which I searched for means of expression beyond the literal copying—such as divisionism and fauvism." These pictures of cats—or perhaps of one cat refigured—seem to represent a brilliant solution to the problem of rendering nature nonstupidly.

Reflection in a Blue Eye
Joan Miró?
Oil on canvas

Note the strong horizontal lines of this composition, which are of inter-
est to students of the surrealist period in that they are clearly suggestive
of the popular pen-and-paper game "exquisite corpse," from which art
writer Dawn Ades claims Joan Miró drew the inspiration for many of the
"strange creatures" featured in his paintings. Is the creature pictured op-
posite "strange" or merely desirous of a bowl of Catalan anchovies and a
nap in the sun?

Composition with Cat
Piet Mondrian?
Oil on canvas

Much has been made of Piet Mondrian's progression from relative natu-
ralism, through neoplasticism, and finally into the brilliantly original yet
nearly identical paintings that represent his mature work in the de Stijl
movement. This painting might well summarize a moment between the
absolute naturalism of 1898's *Drydock at Durgerdam* and the utter non-
representationalism of 1921's *Composition with Red, Yellow, and Blue*. We
may be privy here to the fate of the artist's wish to paint what is there as
it is overtaken by his desire to see (and show) what lies beyond the figu-
rative.

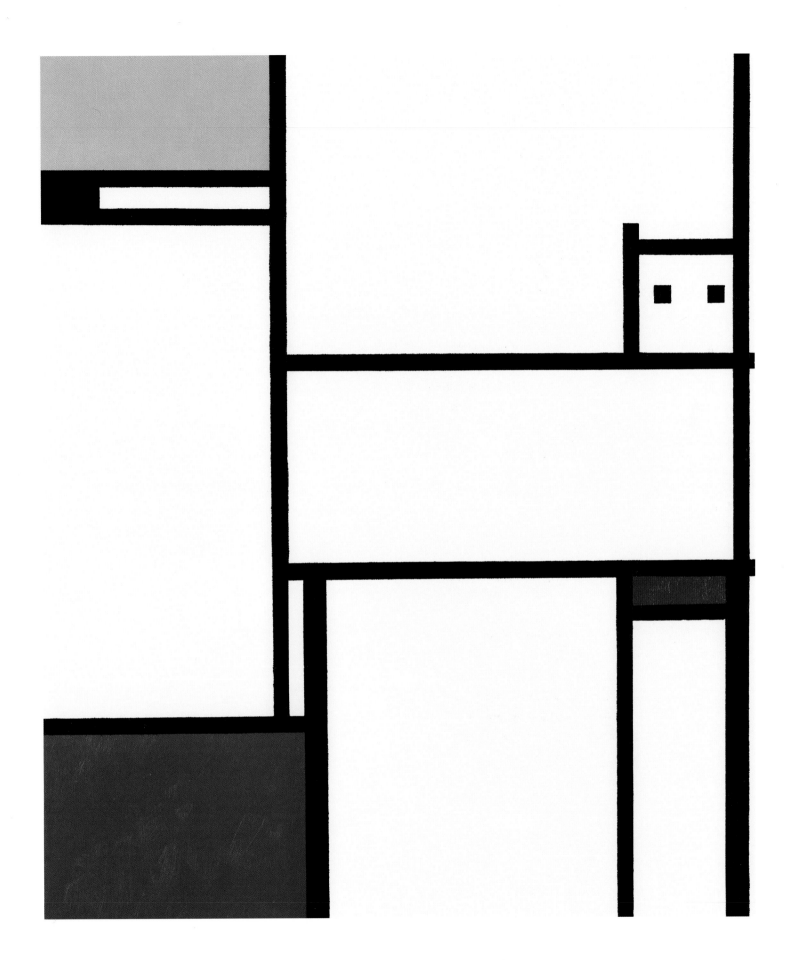

COMPOSITION WITH CAT

Elegy to an Afternoon
Robert Motherwell?
Oil on canvas

Robert Motherwell's archetypally American abstractions with their firm clarity of outline and sensitive, naturalistic yet structured compositions recall Jean Arp's painted reliefs or Matisse's colored-paper cutouts. Yet his work is more informed by the existentialists than either Arp's or Matisse's. And what creature could be more bracingly existent than the gloriously amoral cat?

Cat Box
Louise Nevelson?
Pine and flat latex paint

In interview after interview, the grande dame of American sculpture has equated herself with her work, creating an overwhelming aura of self-involvement—but *deserved* self-involvement. And what better way to learn—to learn to revel in—obsessive self-involvement than to study closely the ways of the cat?

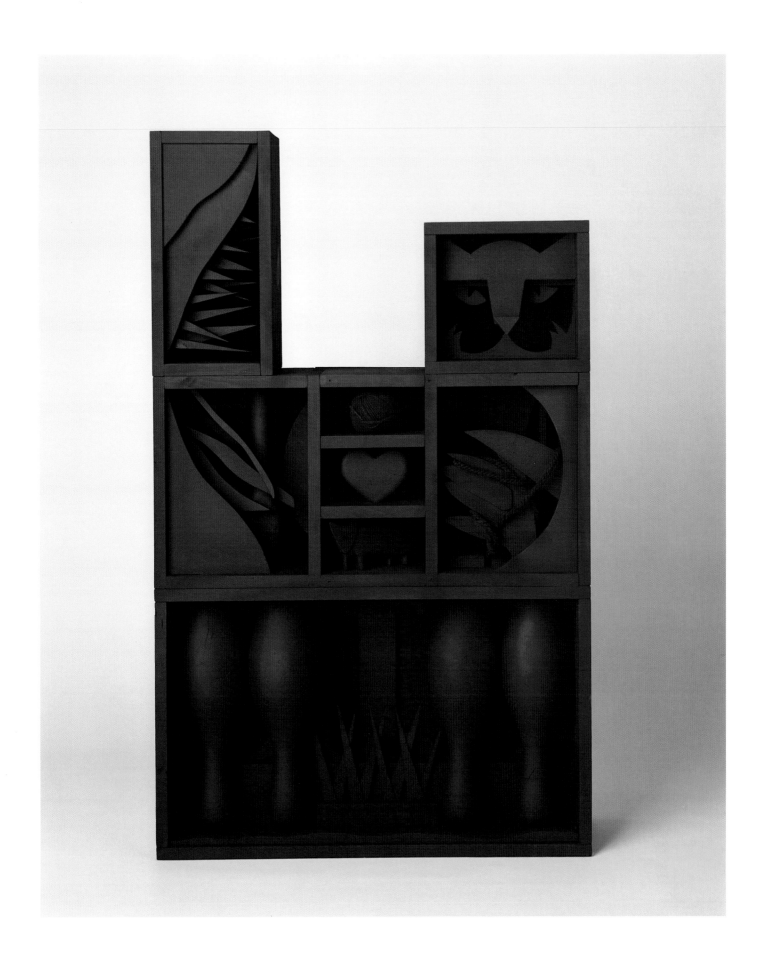

Mountain Lion Skull
Georgia O'Keeffe?
Oil on canvas

A prolific artist, Georgia O'Keeffe produced over 900 works of art, only a few of which are in public collections; she retained a large number for her own pleasure and study, particularly after choosing to pursue her unique creative vision amongst the bones of the New Mexico desert. It is really not unlikely, then, that one work (say, this commanding portrait, perhaps) could have gone uncataloged, unknown. All the classic O'Keeffe elements are here—the fascination with the shape and texture of bones and the uncomfortably familiar and natural interplay between their positive form and the negative space that filled not only the skulls, but also the desert, the average cat's head—and perhaps even the artist's life.

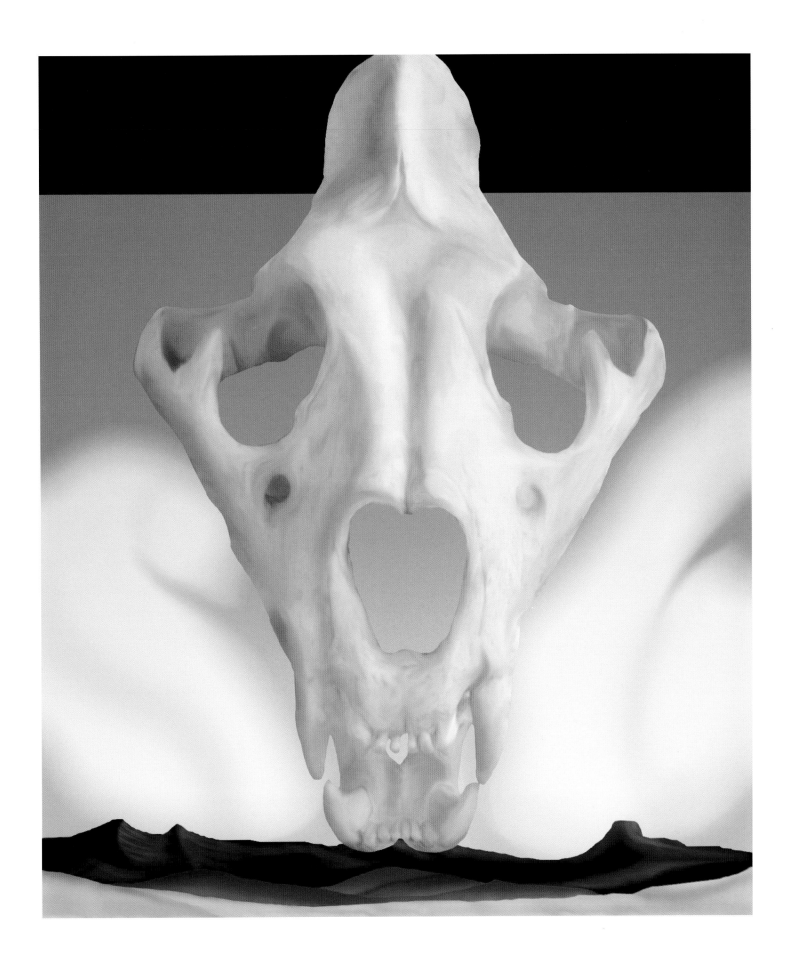

Literary Lion(es)s

Claes Oldenburg?

Photomontage

If nothing else, Claes Oldenburg has been a sculptorly Loki, an intellectual pop trickster less commercially oriented than Warhol, less self-consciously the "artist" than Lichtenstein or Dine. His "happenings" were always about objects and were generally literary in some sense. That this photomontage (and the accompanying sketch, at right) is a nonhappening happening—that is to say, a photo of an event that never took place—would fit in the playful tradition that this most untraditional of sculptors established for himself and his viewers/participants/coconspirators.

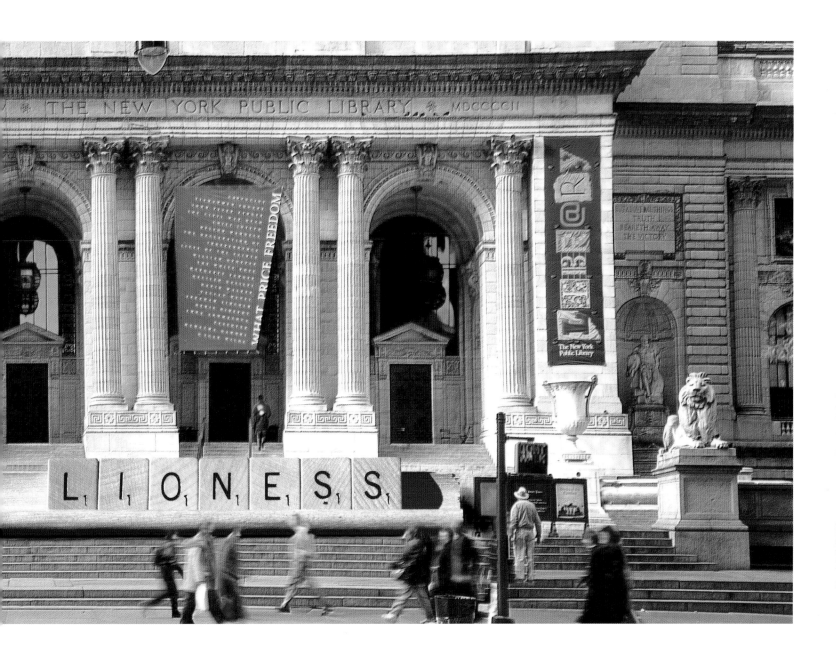

Tribute
Pablo Picasso?
Photomontage

As with the pieces pictured on pages 18 and 57, this is one work that clearly was never executed: a playful alteration of the famous Chicago public work. There is a famous story of a beachgoer who encountered the great artist *à la plage* and had the gall to ask for an original Picasso; the master agreed to this outrageous request, then took a stick and drew a sketch in the sand, where the tide would soon wash it away. Can we not see this as the same sort of act—the willful creation of a masterful tribute that will not, cannot ever be erected, and hence is inherently self-canceling? I believe that we can.

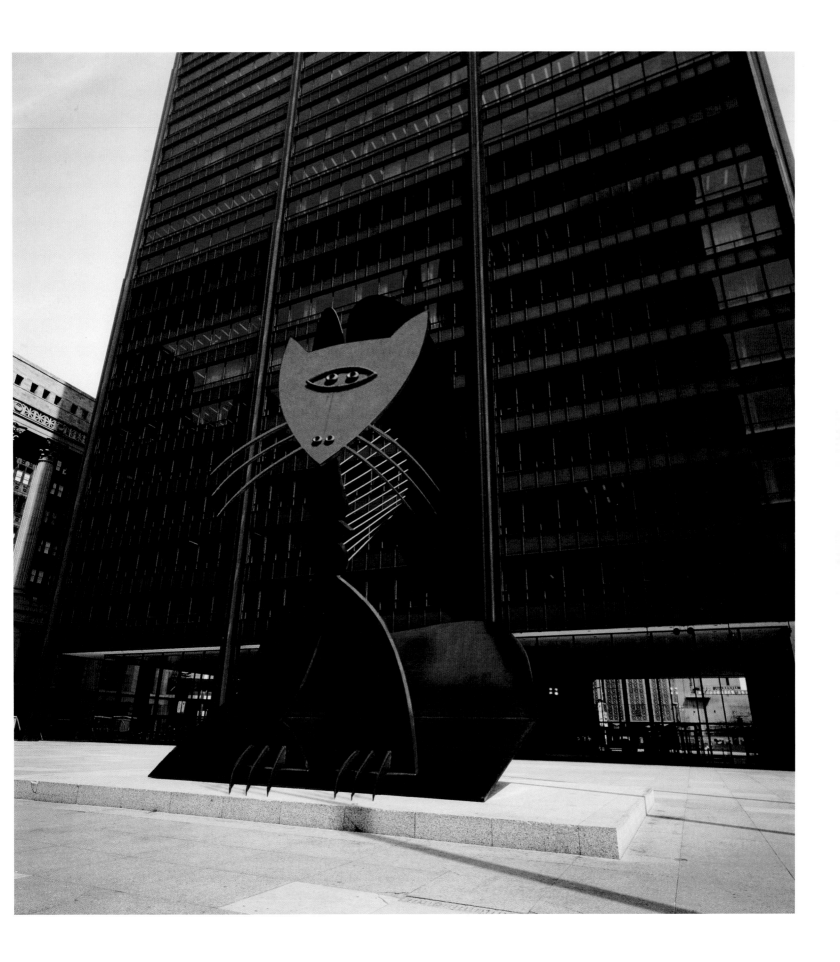

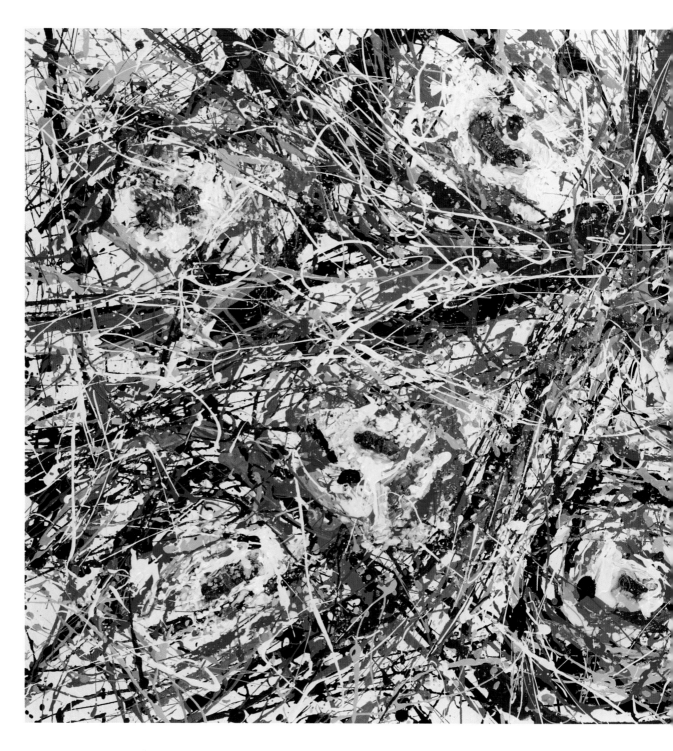

Brown Number 2
Jackson Pollock?
Acrylic paint, cat feces, clear epoxy on board

Pollock has been both accused of destroying painting as we know it and touted for freeing line from its function of defining a subject—freeing it, indeed, from even *being* a line. Instead, he turned it into "frozen jazz,"

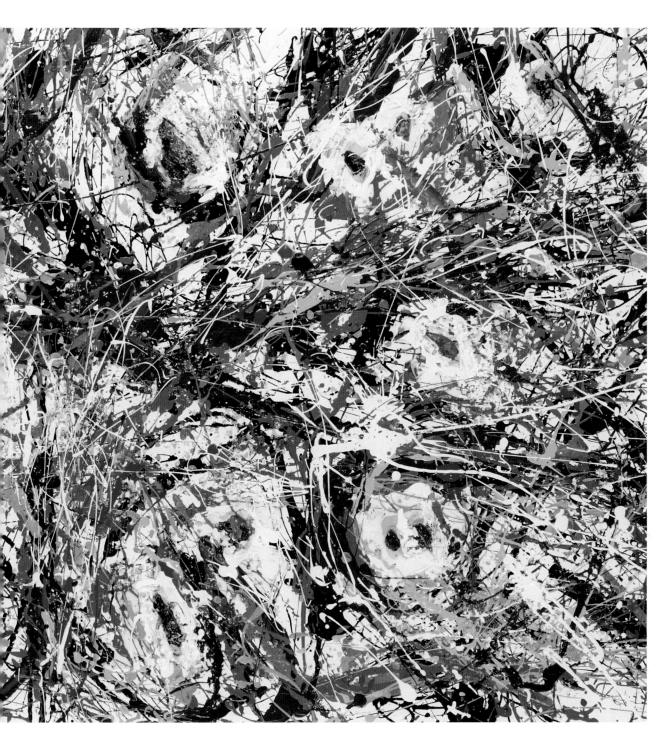

with blobs, smears, chunks, and capillaries of paint and debris. And one needn't be a neo-Freudian to read volumes into this childlike glee at smearing about the wastes one creates, as well as those created by others. This piece, of course, features "number two," moving the use of "found objects" to a fundamentally new level in American art.

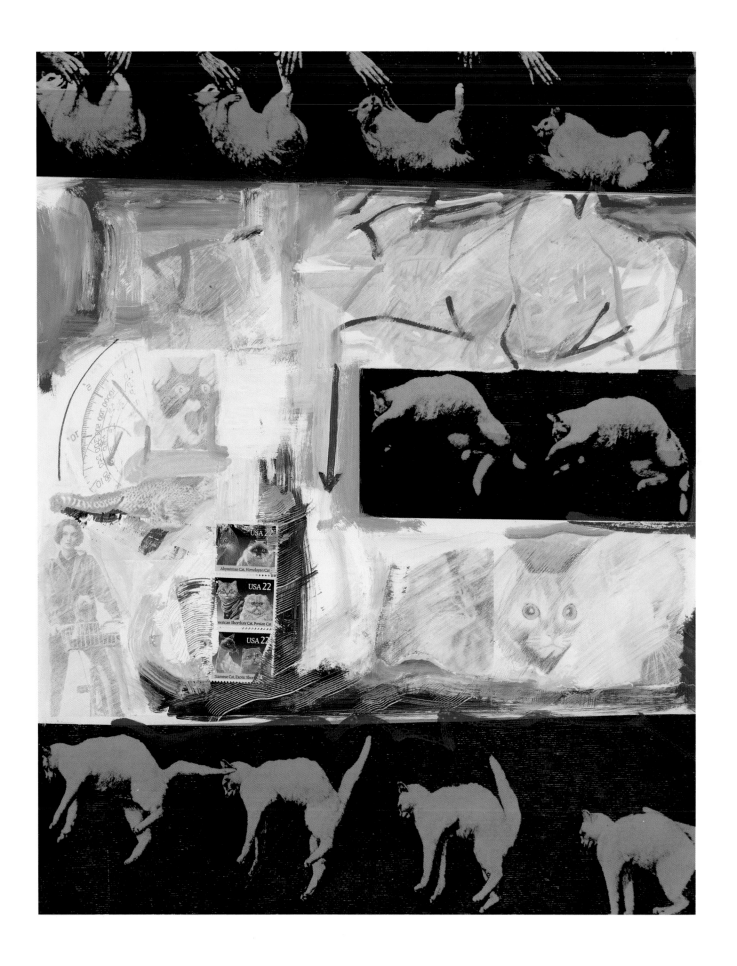

COMPOSITION WITH CAT

Free Fall
Robert Rauschenberg?
Collage of silk-screened and transferred photographs, postage stamps, oil and acrylic paints, and clear epoxy

Robert Rauschenberg's involving collages take the techniques established by cubist and futurist artists to the next logical step by not only *employing* found materials, but virtually building visual altars to them. Rauschenberg has said that he views art as "a matter of accepting whatever happens" (quite a catlike detachment from the dreary bonds that reality places on the nonartistic temperament), and that his works of creation are, rather, a "collaboration" with the real world. Here, a strong case could be made for a collaboration with an only partially cooperative feline companion; in any event, this piece sums up in its jarring juxtapositions and ironic fragmentation the dilemmas of living in an overstimulating, malconnected modern world.

Black and Green on Red
Mark Rothko?
Oil on canvas

After a brief flirtation with surrealism, Mark Rothko began to create the distinctive abstract works that many critics consider to be among the purest, most powerful paintings ever created. His great canvases of the late 1940s and early 1950s, such as *Red, White, and Brown*, are enormous, gorgeously bare expanses of layered color in which subject matter has been reduced to the minimum. Here, perhaps, we see a teasing reminder of his surrealist past, the barest suggestion of an actual subject peeking catlike out of that glowing activity of inactive pigment. Charles Harrison has written of "the often vestigial presences within [Rothko's] canvases," and this piece seems a textbook example.

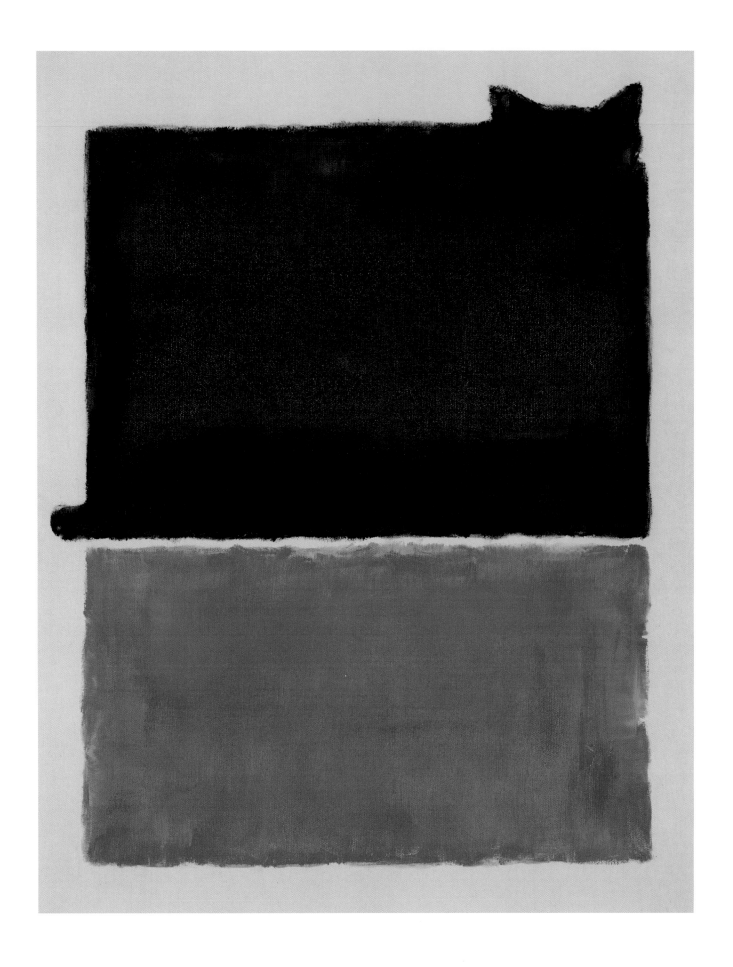

Indecision
George Segal?
Plaster, cement, metal, and lights

Since the 1960s, George Segal has been creating his signature sculptures, wrapping friends, relatives, and models—and perhaps even house pets— in plaster-soaked bandages to create hollow yet astonishingly fertile images. He then often combined these images with objects suggesting the plaster figures' relationships to the outdoor world—windows, bus stops, traffic signs. With this piece, we feel an immediate combination of relief (ah, the cats are not jaywalking) and anxiety (yet they are out on the street!) that seems to comment keenly on Segal's career-long fascination with negative and positive forms and spaces, emotions and reactions.

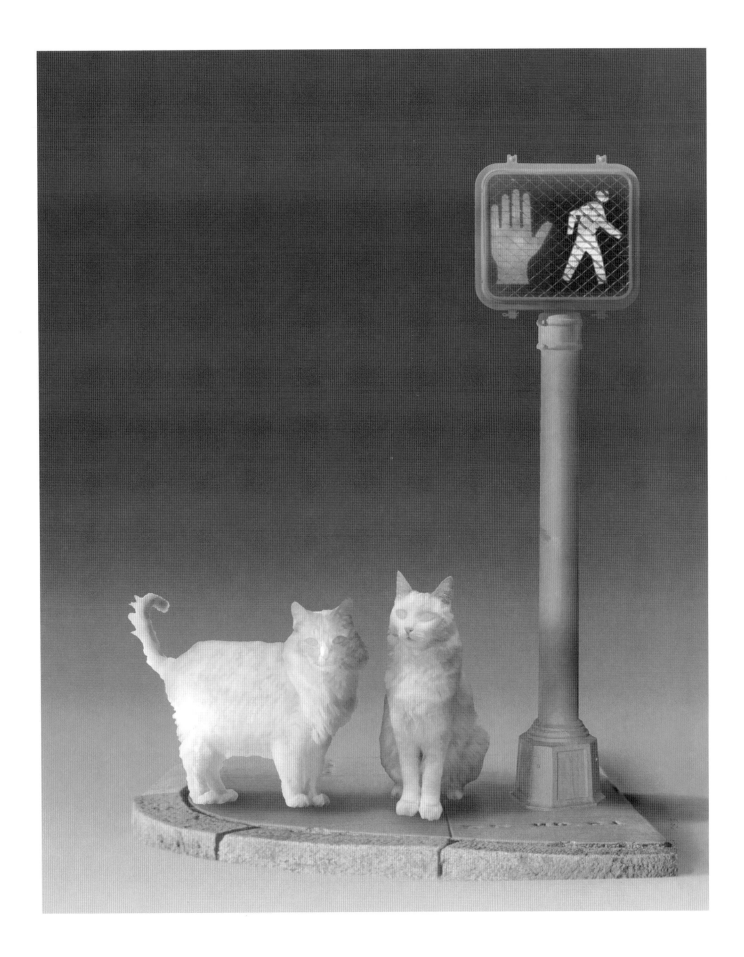

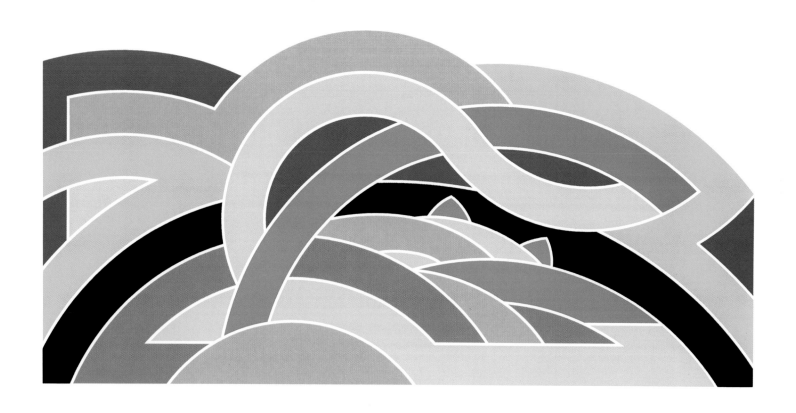

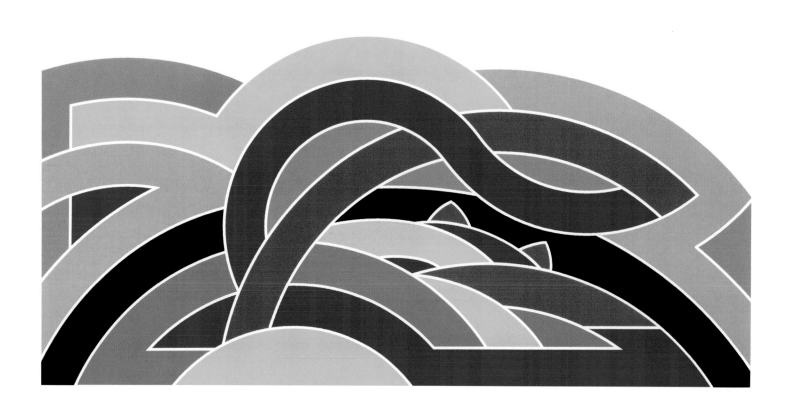

COMPOSITION WITH CAT

Cattail
Frank Stella?
Acrylic on canvas

When Frank Stella's smoothly nonfigurative—some might even say utterly monotonous—paintings were first displayed in 1963, they were mocked by the art community, the same community that now considers them a brave, heroic leap forward, a defining point in modern art. In these two panels, strongly evocative of Stella's mid-'60s works that prefigured yet paralleled pop art, arcing bands of color fill the canvas, entering into a dialogue with the white background; a dialogue that seems to reflect the swishing of a cat's tail—happy and sunny in the first piece, moody and bilious in the second.

Black Cat Shadow
Wayne Thiebaud?
Oil on canvas

Wayne Thiebaud's landscapes are considered his most traditionally "genre" works, yet in their characteristic distortion of perspective and selective emphasis of elements that would be either ignored or slavishly rendered by a lesser painter, they speak volumes about one man's psyche. "I'm not interested in the pictorial aspects of the landscape," he has said, "…but in some way to manage it, manipulate it, or see what I can turn it into." And if one had a beloved black cat, might one not turn such a landscape into an homage to that cat, a tribute loving yet nonetheless filled with the physical pressure and the empathic tension that characterize the best of one's work?

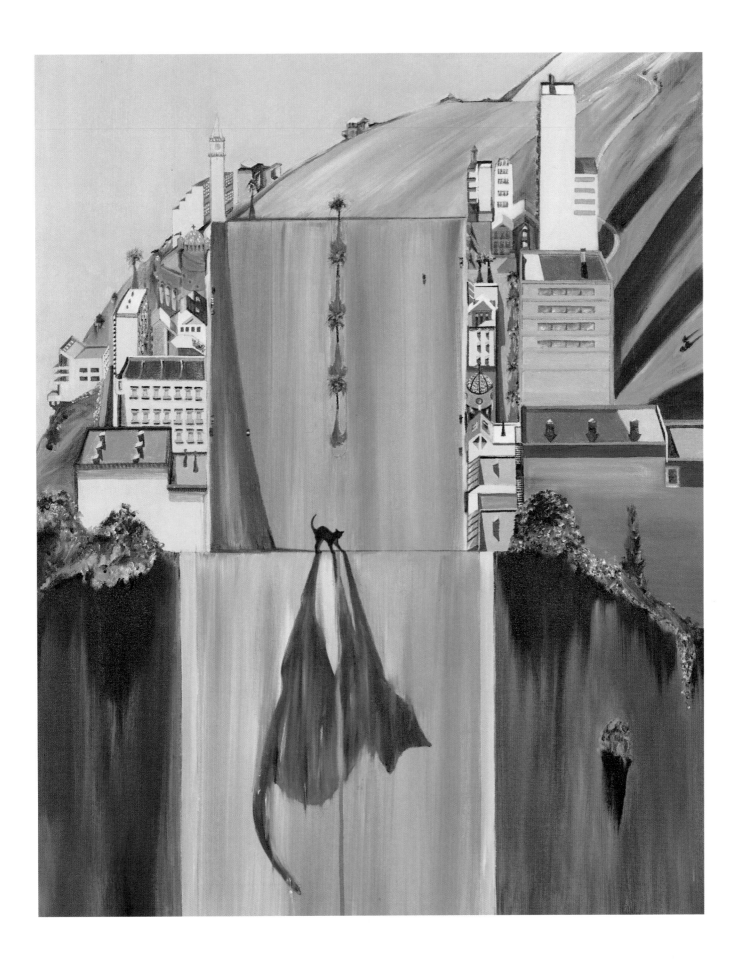

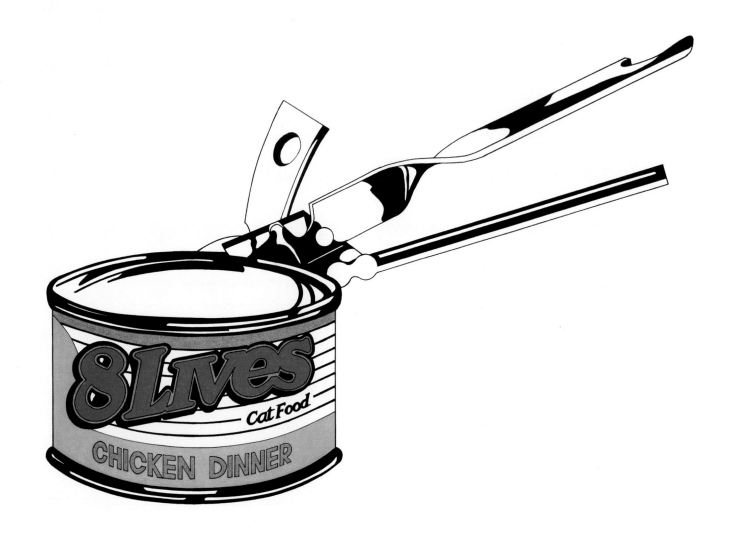

COMPOSITION WITH CAT

Eight Lives
Andy Warhol?
Synthetic polymer paint on canvas

Andy Warhol began his career as a commercial artist, and nowhere is that background more clear than in his "product" paintings: Campbell's Soup, Brillo, and perhaps, this can of "Eight Lives," which provides ironic comment on both the artist's preoccupation with his own mortality and his oft-stated desire to mechanize—to actually become a machine. (He once told a critic, "The things I want to show are mechanical. Machines have less problems.") The Campbell's Soup paintings were, he claimed, inspired by his having eaten the stuff every day for years. What, then, is more likely to have inspired both a fascination with machines and a desire to paint such a painting than mechanically opening food for hungry cats, day after day?

Four Peters
Andy Warhol?
Synthetic polymer paint screened on canvas, and oil sticks

Perhaps the most famous of all of Warhol's silk-screened "portrait" images is that of Marilyn Monroe; the subject is made intentionally both hyperglamorous and somewhat hideous by being mechanistically reproduced with off-register color—trapped, as it were, in the image of her own fame. This sort of treatment might well have been perfected a bit earlier, in Warhol's experiments with Polaroids of such Factory cats as Peter, a beautiful and freeloading (and talent-free) Persian—the perfect Factory denizen, one might say. Warhol always refused to read anything into his art, allowing any interpretation to come from the viewer, but one might well imagine that someone surrounded by cats would come to see them all as one—the same yet different—and perhaps to reiterate that multiplicity through such a *faux naïf* presentation as this.

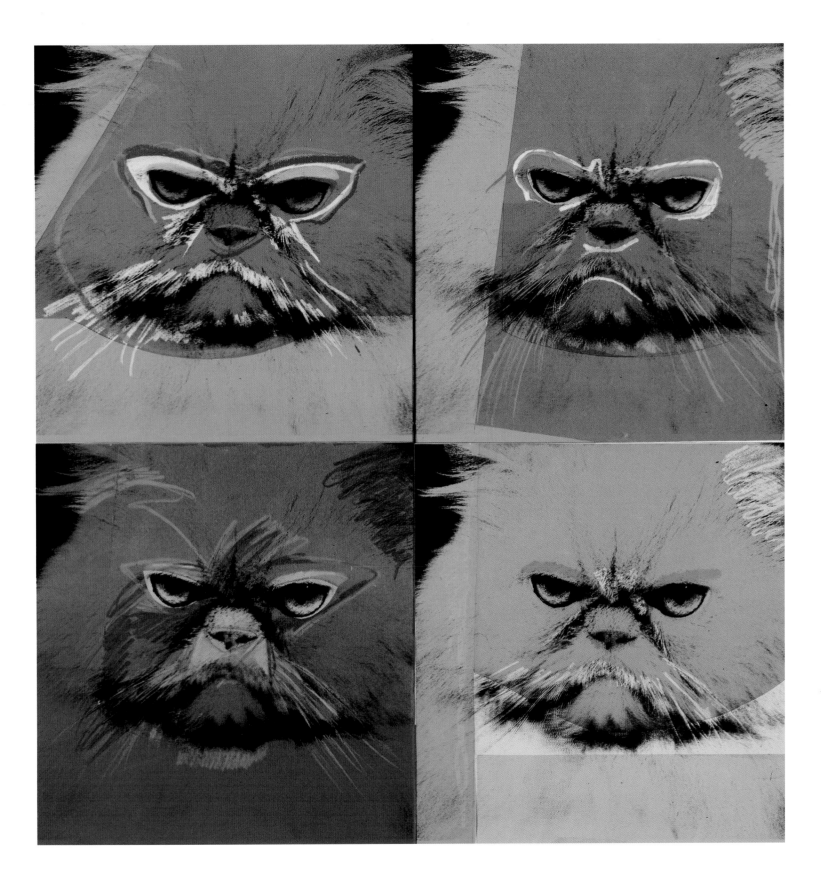

BIOGRAPHIES

Coco Calder

(1955?–1966)

We cannot be sure whether Alexander Calder's kinetic kitty, Coco, ever inspired the noted painter and sculptor's work; but an (apocryphal?) anecdote hints at her potential as a muse. A rather frenetic tabby, she was known for tearing about the artist's Roxbury studio, knocking over vast stacks of art materials...perhaps the inspiration for such assemblages as *Fishy* (1962), *Whirling Ear* (1957), and others? In addition, we know that Calder relished making portrait drawings and caricatures of friends and notables of the era...and surely what was good enough for Calvin Coolidge, Jimmy Durante, and Josephine Baker would be good enough for the erstwhile Coco.

Java Christo

(1957?–1969)

According to Sally Yard of the Princeton University Art Museum, several precedents have been cited for Christo's art, including Man Ray's surrealistic 1920 photo *The Enigma of Isidore Ducasse*, and Henry Moore's 1942 watercolor *Crowd Looking at Tied-Up Object*. The artist himself has said that his famous wrappings have no one inspiration, although he points out that the practice is at least as old as the mummies. This interest in mummies may well have inspired the Sphinx work pictured herein, and reinforced his already strong connection to cats, gods of the Egyptians. Indeed, one may speculate that the entire wrapping fascination might have really had its genesis in an event in the late 1950s, wherein young Java unrolled twelve rolls of toilet paper in the artist's Manhattan apartment, effectively wrapping everything in sight. Christo's first wrapped work, a paint can (1958), appeared mere months later.

Claws de Kooning
(1939?–1957)

While much has been written of artist Elaine Fried de Kooning's influence on her husband's boundary-crossing works, less is known of what effect his standoffish yet lovable Persian, Claws, may have had on Willem's ability to face and overcome the aesthetic crisis of art in the post-Depression era. Alternately abstract and figurative, unsalable and vastly profitable, color-splashed and monochromatic, de Kooning's paintings in many ways reflect the archetypal cat personality: adoring one moment, slashing your flesh the next. And of course, even the plumpest Persian is a creature of surpassing flexibility. For an artist who was alternately coddled and slashed by the New York intelligentsia, what could have been more inspiring?

Jujube Dine
(1969?–1971)

Pop art sensation Jim Dine was best known for works that featured real "found" objects with gaily painted surfaces. If he could tart up a lawnmower, as he did in one notable piece, it is surely no stretch of the imagination to picture him lovingly crafting a personalized scratch post for his beloved Jujube, allowing groovy happenings to take place right there in his apartment next to the litter box, anytime his feline companion desired. Indeed, a tragic, unintended "happening" may have occurred when Jujube, not the brightest of cats, is said to have gnawed into a painted bicycle tire in the studio, ingesting toxic levels of gesso. If true, this may help to explain the oft-asked question of why Dine suddenly switched from sculpture and happenings to more conventional oil paintings as his preferred medium of expression.

Mop Dine
(1971–1983)

As Jim Dine moved away from sculpture, his work often featured a fascination with heart shapes, said to symbolize his love for his wife. But might there not have been another great love…or at least a small, furry one? Similarly, paintings featuring bristled textures, such as the *Tools* series in the early 1970s, have been seen as emblematic of a rather single-minded obsession with pubic hair. But as anyone who has ever lived with a cat can tell you, one needn't have a fascination with human hirsutism to see the world and everything in it as covered in fur. Particularly if we accept the contention that Mop, acquired to replace the lamented Jujube, was a rather long-haired creature, it follows that the artist would see fur everywhere.

Jules and Jim Dubuffet
(1944?–1951)

Rumor has it that Jean Dubuffet's *deux chats*, Jules and Jim, who were inseparable, mysteriously disappeared on the same day in 1951, during the artist's brief sojourn in New York (the period during which—ironically—he painted the renowned *Inhabited Heavens* series, not knowing that his young muses were themselves perhaps about to inhabit kitty heaven). A disgruntled Parisienne housekeeper with severe allergies was implicated in the disappearance, though nothing was ever proven, and *les gendarmes* remained callously uninterested. The plate pictured on page 27 seems to speak poignantly of inseparable littermates, as well as contributing to the playful "amusement of the common man" that the artist once claimed was his true goal in creating all of his pieces.

Spartacus Hockney
(1963?–1972?)

David Hockney cannot be truly said to belong to any school of art—he is a discipline unto himself. However, in examining his works of around the time he is believed to have shared his life with a precocious young feline by the name of Spartacus, we note a marked preoccupation with water. From *Man Taking a Shower in Beverly Hills* (1964) to *Picture of a Hollywood Swimming Pool* (1964) to *Sunbather* (1966), swimming pools and water appear over and over. A clue for the alert student of Hockney's oeuvre is provided in the rather forlorn *Rubber Ring Floating in a Swimming Pool* (1971), considered critically to be a rare example of near-abstraction, but which is perhaps actually a document of the real-life habit Spartacus had of losing his toys in the artist's pool. This may well have inspired the somewhat fantastical notion of a cat that actually enjoys water, which is strongly suggested in the plate shown on page 28.

Greta Hopper
(1934?–1945)

Edward Hopper has been called "the painter of American silence," and no doubt this preoccupation with quiet, still places is what drew young Greta, a serious cat of somewhat skittish temperament, to the great American realist—an association that surely moved beyond the banalities of feeding and petting and into the synergistic realm of artistic collaboration. The painter's feline-influenced sensibilities can surely be inferred from such works as *Sun on Prospect Street* (1934) and the elegaic *Morning Sun* (1952), both of which clearly comment upon a cat's propensity for basking. We find another hint of Greta's influence in the 1939 *Cape Cod Evening*, in which a couple look in seeming anger and disgust at a collie—much as Greta herself would have viewed such an intruder into her and Edward's American silence.

Caspar Johns
(1972–1981)

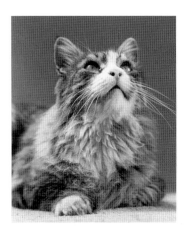

Sources close to Jasper Johns describe what might most charitably be termed a problematic relationship between the artist and his feline companion and muse, the impeccably dignified Caspar. Johns, himself a well-respected and quite dignified artist, saw no debasement in creating artworks such as *Skin I* (1973) and *Skin II* (1973), in which he coated his buttocks and genitals in oil and graphite, then pressed them against paper to create a truly personal artistic statement. It is rumored, however, that when he tried this approach with Caspar, something of a bloodbath resulted. Still, the image pictured on page 32 is reminiscent—if not verifiably a product—of the artist's stencil phase, so perhaps this set-to was only a minor setback in the artist/muse relationship.

Red Kelly
(1954?–1962?)

Unlike those of his pre-pop contemporaries, the details of Ellsworth Kelly's life and loves—and hence of his all-important animal attachments—have escaped the blinding light of critical analysis. It has been said of him that his greatest joy was in playing the third dimension against the second, something only too common when a three-dimensional object (such as a large orange cat) lies down upon a two-dimensional surface (say, a drying canvas). Food for speculation is not wanting: a number of period photos do depict what was most probably his cat; also, criticism of Kelly's influences describes his fascination with seemingly simple forms that become ambiguous—an apt description of what one observes when watching a cat go through its gyrating ablutions.

COMPOSITION WITH CAT

Dot Lichtenstein
(1960–1969)

One word constantly used to describe Roy Lichtenstein's work is "playful," and few furry folks can honestly be described as more playful than little Dot Lichtenstein. A former model for Kute Kitties Kalendars and inveterate newspaper shredder, she is said to have kept Roy frolicsome during his highly disciplined painting stints in Southampton. Indeed, one story (told by an intimate of the artist) has her actually providing the inspiration for some of his greatest works: While he was trying to re-assemble a particularly thrilling Sunday installment of Apartment 3-G after Dot's depredations, he was forced to really observe the dots that make up a newsprint cartoon—and the rest, as they say, is history.

Princess Louis
(1955?–1964?)

Morris Louis painted in complete privacy, so history has no record of exactly how he created his paintings or what may have inspired him. The works are intended to stand on their own and, largely, they do. Interestingly, they can also stand on their sides or upside down—Louis played with hanging his paintings differently at different times, displaying what only the most untrained of observers could fail to recognize as a very feline flexibility—a willingness to come to rest in just about any position. If greater evidence of catly inspiration need be gleaned, perhaps we can look at the numerous late-1950s works in which Louis took to hanging, according to art critic Michael Fried, "tails" of pigment from the bodies of his works. An interest in stripes, a solitary personality, a predilection for tails…it all adds up, does it not, dear reader?

Chien Magritte
(1939–1946)

Even the most casual admirer of surrealist expression in its multiplicitous and glorious forms is aware that the seminal painter René Magritte felt his work to be primarily motivated by a deeply ingrained sense of the absurd, coupled with the lifelong "bizarre affliction," as he termed it, of terminal ennui. *Trés* French, yes, *mais trés félin aussi, n'est-ce pas?* And the cat's name? No one knows for sure, but a humorous anecdote making the rounds of Paris cafés in the 1940s had it that Magritte originally intended to name his beloved pet cat "Ceci N'est Pas un Chat," but that he became angered when macho pals such as André Breton took to calling the cat "Sissy." (It was an "altered" tomcat, and perhaps the artist, in a bit of Gallic-male projection, felt the cat's manly pride would suffer too much from such an easily-mocked name.)

Fauve Matisse
(1903–1913)

A number of critics (all of whom are personally known to the author, though few of whom, granted, are actually read) have compared Matisse's Fauve to Wyeth's Helga—only of course feline, not human; French, not American; and sans those fetching braids. Still, the idea remains that both of the plates pictured earlier (pages 43 and 44) may have been inspired by the artist's clearly avant-garde house pet, as may some better-known works from the painterly portion of Matisse's career, such as the 1907 *Interior with Goldfish*, in which the reclined figure of a nude woman is featureless and clearly secondary to the sharply rendered—dare one even say fascinating—fishbowl. It could well be argued that only an artist truly in tune with his cat could find *les poissons* more intriguing than *la femme*.

Gato Miró
(1923–1937)

Joan Miró was known for attempting always to name his paintings as simply as possible—it was his agents and surrealist associates who attempted to give them much more complicated monikers. So perhaps the astonishingly mundane name with which he stuck his feline companion was not the product of a lack of creativity—it would be hard to credit one of the greatest painters of our time with such—but a sly surrealist joke, a *petit,* if not petty, triumph over gloomy colleagues such as Max Ernst, who is said to have named *his* cats after only the most unpleasant of personages. As to how young Gato may have inspired Miró, it may suffice to quote some of the terms used by contemporary critic René Gaffé to describe the Catalan genius's work: "savage, insolent…, sumptuous, luxurious, festive, and magnificent….despotic, masterful, absolute, all-powerful, and supreme." No one who has shared a home with a hungry cat could possibly fail to see a correspondence. Was Gato hungry, despotic, and magnificent? Is any cat otherwise?

Stijl Mondrian
(1919–1927?)

Much has been made of the dramatic changes in Piet Mondrian's work: the difference between his Dutch-era paintings of pastoral scenes and what some have called the "obfuscating idealism" of his neoplastic work. Was he influenced by such modernistic forces as Bart van der Leck and Theo van Doesburg? Did he share with Wassily Kandinsky a sustaining belief in the spirituality of pure line? Or did he perhaps get a cat? It has been suggested that once Stijl entered the painter's life, Piet was suddenly forced to truly notice the number of square things in a world that up until then he had seen as suffused with a multiplicity of shapes. Now, the litter box, the cat-carrying case, the door that must be opened, then shut, then reopened, the box of kibble: all of these may have drawn the artist inextricably to the sense that the world as it truly exists *is* in its very nature composed of squares. For this realization, art may owe Stijl a very great debt indeed.

Paws Motherwell
(1950?–1955?)

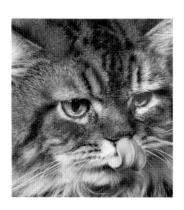

Robert Motherwell's place in the pantheon of American artists is undisputed. However, it is interesting to note that in the ample literature on his work and life, there is always a discussion of a central mystery: to wit, the fact that his works are almost equally divided between the "monster" pieces (such as 1959's *Monster for Charles Ives*), reflecting a view of the darkly monstrous aspects of life; and his more lively, ecstatic, playful works, such as the happily leopard-spotted *Collage* (1947). But as we have already seen time and time again, any familiarity with the complex relationship between human and cat (that mythical melding of monster and muse) could not help but shine a veritable spotlight into the darkest corners of this (by now patently transparent) mystery. And if the gossip of the time is accurate, Paws was a particularly mercurial cat—snuggling up to be petted one moment, viciously biting the stroking hand the next. No wonder Motherwell so often found himself in an existential crisis!

Lili Nevelson
(1966?–1986)

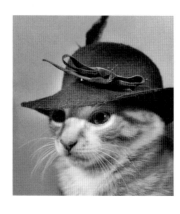

One of the defining characteristics of Louise Nevelson's life—along with her penchant for fancy headgear, her rich iconography of imagery, and her oft-criticized obsession with presenting the most glamorous face possible to the world—was her intense guilt at what she saw as her failure as a wife and mother. According to biographer Laurie Lisle, Nevelson's growing dedication to art led her to leave her husband and neglect her son, over which abandonments she suffered lifelong guilt. Is it not then altogether likely that such a self-involved yet guilt-racked woman would become attached to an animal that allows nurturing yet rejects fussing…an animal such as the thoroughly self-involved Lili?

Abiquiu O'Keeffe
(1947?–1952)

After the death of Georgia O'Keeffe's husband and artistic mentor, the noted photographer and modern art promoter Alfred Stieglitz, O'Keeffe shocked the art world by moving to New Mexico (where she had retained a part-time residence for decades) with a cat more than sixty years her junior. There is no suggestion, however—aside from the insinuations of truly sick individuals in the art community—that the relationship was anything other than that of artist and muse. Still, it is interesting to speculate that O'Keeffe's annoyance at wagging tongues back in New York may have caused her to picture little Abby (as she is said to have affectionately called him) as not only deceased, but as a mighty cougar to boot, rather than the somewhat insipid little kitty pictured at right.

Cotton Oldenburg
(1959?–1964)

Oldenburg the artist gives every indication of a man virtually at one with his cat: the noted obsession with food; the need for soft, interesting textures; the innocent yet all-consuming desire to stand up before the world on one's hind legs and say "Look at me!" Even in his choice of artistic technique, a feline inspiration seems to have been present, as we can discern from this 1961 quote: "I like to work in material that is organic-seeming and full of surprises, inventive all by itself....I am naturally drawn to 'living' material, and it gives me great pleasure to experience the freedom of material with my hands." This has been understood to apply to his soft sculptures, such as 1962's *Giant Piece of Cake*; but I think that upon reflection, we can see this statement as the words of a man who just really likes to play with his cat, then go make happenings happen.

Maître Picasso
(1956?–1970?)

In few cases is it as unnecessary, I feel, as in this to stress the catlike nature of the artist in question—and hence the almost unavoidable inference of a felo-human artist/muse relationship. In discussions of Pablo Picasso, the phrase "no false modesty" rings out over and over. Self-obsessed, demanding, difficult, and vigorous; possessed of unquenchable appetites and an unswerving assurance of his own right to be and do exactly what he felt necessary: Picasso, in everything but the fur, the short lifespan, and the tendency to kill and eat small mammals and lizards (trifles, mere trifles, one must argue) *was* a cat. Throughout his long life (might we even suggest, given his wide range of styles and media, his more-or-less *nine* lives), it is understood that Picasso had a number of cats, all named with equal grandeur. But an examination of their portraits suggests that it was the stately Maître, rumored to have been a gift from Norman Mailer (whom the cat also does a bit resemble), who provided the inspiration for *Tribute.* Something about the expression, perhaps.

Bingo Pollock
(1946–1955?)

Perhaps no cat-muse has ever enjoyed as much freedom as little Bingo Pollock. Whatever he did—tear up canvases, gnaw bits of wood into splinters, even urinate and defecate in the studio—his owner greeted with indulgence, even encouragement, as he picked up the pieces and used them in his groundbreaking works. Bingo was a rather hyperactive kitten; it could even be hypothesized (by those more daring than ourselves?) that his very temperament provided the impetus for Jackson Pollock's shift from more cubist-influenced works to the freer, more radical "action" paintings with which his oeuvre reached its apotheosis. Indeed, Robert Motherwell himself described Pollock's painting method as frantic, even violent. From this we can infer that his process was much like the movements of a cat who has decided, against all odds, to finally have it out with the catnip mouse we call existence.

Rebus Rauschenberg
(1969?–1979)

In a simple yet elegant summation of his artistic vision, Robert Rauschenberg has stated that "a picture is more like the real world when it is made out of the real world." In the artist's work, this has often meant the use of such elements as pictures torn from magazine, bits of wood, and postage stamps; it seems logical that photos of his cat, Rebus, might well form the focal point for a "collaboration with the real world." It is also interesting to note the amount of torn paper that appears in Rauschenberg's work—anyone familiar with the literary criticism of the average cat (e.g., the willingness to destroy the latest *ArtWeek* before you can even exclaim in horror at the reviews) might well detect an influence. And a critical familiarity with the cat-created paint-smear works on display at the Museum of Nonprimate Art can only further inform this almost unnerving sense of feline familiarity.

Crumbs Rothko
(1945–1951)

In all of my research on the feline muse, finding hints of Mark Rothko's kitty inspiration has been perhaps the most frustrating—the clues are there, oh yes, one sees them, shimmering in the distance like an abstract-expressionist field of pure-yet-varying pigment, which, as one approaches, dissolves into a serene expanse of nothingness, much like Rothko's most challenging paintings. It is noteworthy that while Rothko has been discussed as a painter attempting to escape nature and naturalism, still many of the colors with which he chose to blanket his imposing canvases are colors we find most prevalently in the litters of kittens with which nature litters lower Manhattan, where this daring escape was being conceived. Black, brown, orange….Rothko, in a famous statement, said he sought to find man's "eternal symbols"—and perhaps he did, right there in the blanket-lined cardboard box where he first saw and fell in love with the color-blocked kitten immortalized yet negated throughout his work.

Wiro Segal
(1962?–19??)

The story of Wiro Segal, while perhaps entirely apocryphal, is nonetheless not a happy one. It is said that George Segal, who is known to have created his noted wrap sculptures using friends and loved ones, drove away his beloved cat by trying to wrap him one time too many. After that, the story goes, he spent hours gazing out the window at cats crossing the street near his New York apartment, perhaps providing the inspiration for the piece pictured on page 67—although whose cats he might have wrapped to create it remains a tantalizing mystery.

Sinjerli Stella
(1963?–1969)

Frank Stella had something to say, although he himself wasn't always entirely sure what it was. Critics found his pieces tedious, and yet—sometimes in the same sentence—filled with urgent energy and velocity, immediately arresting in their sensuous directness; much, indeed, as people found little Sinjerli, a cat whose obsession with yarn, string, and even twine may well have inspired the artist's concentration on the stripe. In discussing his artistic development in terms of abstract expressionism, Stella once said, "What I liked was the openness of the gesture, the directness of the attack." A description of the abstract expressionists or of a kitten with a ball of string? Must we really choose?

Blacky Thiebaud
(1970–1979)

Wayne Thiebaud's father supported his family by working in the machine shop of a creamery, and a proximity to the cats who clustered about the creamery, hoping to capitalize on some spilled dairy products, is quite likely to have begun the lifelong affinity of the artist for the opportunistic creatures. It is also interesting to note that Thiebaud's first well-known works were depictions of such food items as ice cream and hot dogs—items generally enticing to even the most finicky of cats, as Blacky was rumored to be. It is perhaps this interrelationship between pets, art, and food that the artist was referring to when he said, "There's something I find fascinating about making a circle of butter....Fish laid out on a plain white surface are very moving."

Hollywood Warhol
(1966?–1970)

Andy Warhol was an intensely catlike person: a loner, aloof from the world, yet craving attention and adulation; possessed of a seeming nine-lives-worth of fame, yet tragically short-lived in reality; and with a truly compelling pelt. All of these things could be said, too, of the cat reported to be his favorite, a cat named Hollywood—although the famed Factory was, according to contemporary accounts, lousy with cats. This seems likely to be accurate, as it is well known that Warhol shunned inquiry into his private life, while still wishing to create for himself an artificial family, a collection of stragglers, hangers-on, and fabulous creatures. This could equally be said of the humans or of the delightfully boring and unquestioning felines he gathered in Lower Manhattan. For a man obsessed with the boring (most vividly—if that is not a pure oxymoron—in films such as *Sleep* and *Empire*) and desirous of mechanical routine, the daily grind of opening food cans and cleaning the litter box must have been unutterably soothing.

ABOUT THE AUTHOR

William Warmack is an artist, graphic designer, and writer. He lives in San Francisco with his longtime companions Sandra, Otto the parrot, and Tati the cat.

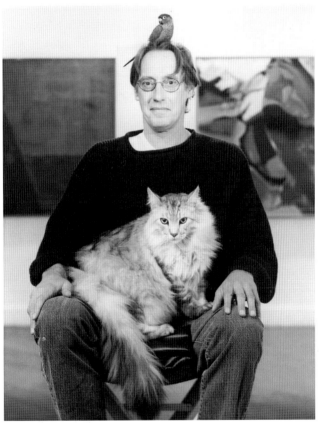

© PAUL SCHULZ

The text for this book is set in 11 point Garamond 3 with display type in Futura Condensed. Like the art contained herein, these faces combine classical and bold modernist elements, and are furthermore characterized by sleek yet full-bodied proportions with complex, slighty tannic down-strokes.

This book was printed at C&C Offset in Hong Kong on 128 gsm Japanese matte art paper, using process colors.